MINIMALISM

0976164	709.016 /TAT	H	

ISBN 1-85437-009-1
Published by order of the Trustees 1989 for
the collection display, 21 March 1989 –
18 February 1990

Published by Tate Gallery Liverpool,
Albert Dock, Liverpool, L3 4BB
Catalogue compiled by Lewis Biggs,
Penelope Curtis and Jemima Pyne
Designed by Jeremy Greenwood,
Liverpool
Colour origination by Axis Photolitho,
Runcorn
Printed in Great Britain by Cox Rockliff,
Liverpool

Photo credits
Tate Gallery Photographic Department,
cover, pages 15, 16, 17, 18, 19, 20, 25, 27
Saatchi Collection, London,
pages 21, 22, 24
John Mills Photography, Liverpool,
page 23
© Carl Andre, pages 22, 23
Dan Flavin, pages 15, 21
Donald Judd, pages 16, 17, 24
Robert Morris, page 25
Richard Serra, page 27
All rights reserved DACS,
London, 1989

Cover

Sol LeWitt
Two open modular cubes/half-off 1972

CONTENTS

4

PREFACE

The Tate Gallery is fortunate in having within its collection an important group of works made in New York at the end of the 1960s and beginning of the 1970s: they were dubbed minimal because the artists chose to reduce to a minimum the means and materials with which they worked. Many were bought almost immediately after they were made, if not from the artists' studios then from the first occasions on which they were exhibited. They represent, therefore, an exemplary period in which acquisitions were made while the art was still contentious, by a curatorial staff that was committed to the art of its own generation. Such a sense of collaboration between artists and curators and between artists and collectors has been an important part of the creation of all the significant collections of art and in particular of the growth of the museums of art in this century. We are delighted to have the chance to show off one of those moments from our own recent past.

At the time minimal art was shocking, not only to those who were struggling to understand the pop art of the previous generation, but more particularly to those deeply involved in the artworld itself. It was an art that challenged the established market, since it refused to comply with the accepted notion of authorship. It took an important step in challenging the convention that an artist must personally manufacture the work of art and establish a new status for the object as art. In what way is the art object different and where does its meaning reside? What is the role of the artist (must he have unique skills, special insight, natural talent?). What is the role of the viewer, what kind of experience should he expect, and indeed what does it mean to understand a work of art?

Those are all questions that we expect to see taken up with renewed vigour by artists during the 'nineties.

This display contains the most controversial purchase made by the Gallery in recent years, Carl Andre's 'Equivalent VIII' (more popularly known as the Bricks). We hope that by showing the work in the context, not only of other works made at the same date but through the generosity of our two lenders alongside two other 'Equivalents', that the significance and intention of the artist is made more clear.

We are most grateful to our two lenders, both of whom have long championed these artists and their art, for agreeing to allow their works to come to us for nearly a year and to Michael Craig-Martin whose text, written as an artist responding to other artists and their work, is most illuminating.

Nicholas Serota
Director, Tate Gallery

Richard Francis
Curator, Tate Gallery Liverpool 5

THE ART OF CONTEXT

Michael Craig-Martin

At the beginning of the 1960s Abstract Expressionism seemed to mark both the triumph of American painting and the emergence of a recognizably new and radical post-war aesthetic.

Today Abstract Expressionism retains its dominant international position in the art of the late 40s and early 50s, but with each succeeding decade its connectedness and continuity with pre-war European art become clearer and its separateness and distinction from the art which has succeeded it become increasingly apparent. This is not to deny or diminish the great originality and achievement of Abstract Expressionism, but to see it as the triumph of early 20th century Modernism in the New World. The confident romantic idealism, the sense of extreme personal engagement, the unselfconscious moral heroism that characterized Abstract Expressionism had their roots in the years of material deprivation and communal social awareness of the Depression and the War.

I was a student in America in the early 60s, part of the generation born during the War but with little direct memory of it, knowing only a world of steadily increasing affluence and seemingly limitless opportunity, a world of the new suburbia and its invention the 'teenager', of rock and roll, television, the two car family, and the drive-in. For my generation of art students, the high-mindedness of Abstract Expressionism, while overwhelmingly admired, created the embarrassed silence of cultural distance.

This is not to imply a lack of seriousness about art on our part (if anything, the contrary was true) but that a self-conscious emotional gap had opened between the artists whose formative experience was essentially pre-War and those for whom it was post-War. For us, the first artists to provide the possibility of instinctive identification were Jasper Johns and Robert Rauschenberg. With the benefit of hindsight, it is clear that these two artists were the first to manifest the dominant characteristics of much of the art of the subsequent twenty years.

Detachment; irony; use of commonplace objects and imagery; use of secondary imagery, repeated units, mechanical processes; linguistic and conceptual concerns; interest in perceptual psychology and the role of the viewer; fascination with both the concept of reductivism and the work of Duchamp; acceptance of meaning latent in different materials and in the processes of making; openness to the use of any and all materials; indifference to the apparent divisions between high and low culture; indifference to the distinction between abstraction and representation; denial of hierarchy; denial of absolute values; commitment to a notion of the radical based on continual questioning of fundamental assumptions; primacy given to simplicity, clarity, directness and immediacy; assertion of the physical rather than the metaphysical or the metaphoric: these characteristics are apparent in the critical art of the 60s: Pop, Minimal, and Conceptual. 'Cool art', in the terms of Marshal McLuhan, rather than the 'hot art' of the 50s.

The conjunction of these new attitudes and ideas created an explosion of creative possibilities; new ways of making and understanding art, new ways of looking at the world. Despite their important and obvious differences, these three movements together, I believe, constitute an aesthetic realm whose radical challenge continues to the present.

When we assumed that radical and fundamental questioning of art and the invention of essentially new forms of language were basic to the nature of all new art, we were wrong. These ideas were, in fact, central to the art of that particular period from the late 50s to the mid-70s and can be seen now to have been the principal determinants of the character of the art of that time. In retrospect it is obvious that the pressure of fundamental innovation was unsustainable, that a new form of academicism was inevitable, and that a period of 'return to the old values' would follow.

The art of the 80s has of course been dramatically different from the art of the previous period, with the re-emergence of painting (painterly, self-expressive, figurative, narrative, romantic, heroic) as the primary vehicle of art. In general, with some individual exceptions, the art of the past decade has depended

for its sense of newness and innovation simply on its difference from Conceptual and other art which immediately preceded it. Particularly in Britain 'the new spirit of painting' has essentially seen the consolidation of the reputations of those painters who have come to be known as the School of London, the character of whose work was already clear by the late 50s or early 60s, and who, I suspect, have never even thought of themselves in the terms of radical innovation, a concept foreign to their conservative and romantic individualism.

What the radical art of the 60s had proposed was not simply new styles of painting and sculpture but an alternative attitude toward art, toward art making, toward art meaning. This is most clear in the continuing challenge of Minimalism.

The public enjoyed Pop art even before it was taken seriously by the art world: people found a lot to 'relate to'. Because Conceptual art never developed recognizable stylistic conventions, and because, in its broadest definition, it came to cover an extensive range of activities, it never intruded in a focused way on public consciousness. Minimalism, with its implication of 'almost nothing there' and, in Britain, because of the notoriety of the Carl Andre 'brick piece', has come to represent everything about contemporary art that makes many people (not just those that are uninterested in art) suspicious and hostile. This reaction is based partly on misunderstanding and partly on a rejection of the radically different values Minimalism represents.

As Barbara Rose pointed out in her article 'ABC Art' in *Art in America* in October 1965, Minimalism arose from a strange synthesis of the two most radical polarities of early twentieth century art: Malevich placing a black square on a white ground, and Duchamp exhibiting a standard bottlerack, a 'readymade'. Malevich with his realization that art did not need to be visually complex to provide a complex experience and Duchamp with his denial of the necessity of the uniqueness of the art object and his realization that art is itself a context were seeking to demystify art and to create an art directly accessible to the viewer without the need of intermediaries, 'interpreters'. The Minimalists shared these aims.

Radical art never creates anything entirely new: it simply shifts the emphasis. What previously was unimportant, taken for granted, invisible, becomes central. Minimalism seeks the meaning of art in the immediate and personal experience of the viewer in the presence of a specific work. There is no reference to another previous experience (no representation), no implication of a higher level of experience (no metaphysics), no promise of a deeper intellectual experience (no metaphor). Instead Minimalism presents the viewer with objects of charged neutrality: objects usually rectilinear, employing one or two materials, one or two colours, repeated identical units, factory-made or store-bought; objects that are without any hierarchy of interest, that directly engage and interact with the particular space they occupy; objects that reveal everything about themselves, but little about the artist; objects whose subject is the viewer.

By shifting the emphasis so emphatically to direct experience Minimalist art makes a clear statement about the nature of reality. Its apparent simplicity is the result of rigorous focusing, the elimination of distraction. It is neither simple nor empty, cold nor obscure. Minimalism reorders values. It locates profound experience in ordinary experience.

MINIMALISM

Now the world is neither meaningful nor absurd. It simply is. In place of this universe of 'meanings' (psychological, social, functional), one should try to construct a more solid immediate world.
Alain Robbe-Grillet
in Barbara Rose

The Minimal artist attempts to state point blank in visual form what philosophers and writers have been saying verbally – phenomenology is the basis of experience; to deal with experience directly, we must stop misusing language to construct ambiguous meanings.
Allen Leepa

The rise of Minimalism was roughly paralleled by that of Pop art. Although the two movements appear radically distinct, they share many essential features, notably the rejection of expressionistic devices in favor of elemental, clearly defined forms – often using repetition or exaggeration to call attention to themselves as conscious gestures. Minimalism differs from Pop art in that it chose not to refer to anything outside of itself, while the Pop artists commented directly upon the consumer society around them.
Anon
catalogue 1982 *Minimalism x 4*

It did not take long for Minimalism to become one of the most uncompromising and pervasive aesthetics for our time, bringing about decisive changes not only in painting and sculpture, but also in music and dance.
Suzi Gablik

Well, I have never been averse to knowing better, or for that matter saying I do, and I say now that I not only know better than the *Daily Mirror* and the *Daily Mail*, but I know better than the people at the Tate who bought a pile of bricks and called it art. I call it a pile of bricks; and that is what it is.
Bernard Levin *The Times* 18 February 1976

Bricks are not works of art. Bricks are bricks. You can build walls with them or chuck them through jewellers' windows, but you cannot stack them two deep and call it sculpture.
Keith Waterhouse *Daily Mirror* 19 February 1976

What matters is the artist's will to discover, rather than the manual skills he may share with hundreds of other artists. Anybody could have discovered America, but only Columbus *did*.
John Ashbery
in Barbara Rose

I think of Minimalism as the last great modern aesthetic. Minimalism sought to demystify art, to reveal its most fundamental character, its reality. It was confident, serious and high minded without being metaphysical or 'spiritual'. Exposing its materials and processes, it attempted to engage the viewer in an immediate, direct and unmediated experience. Minimalism was in essence an attitude, not a style, and the appearance of minimalist work was a consequence of that attitude. The work was uncompromisingly radical and challenging: it proposed a new way of looking at the world.
Michael Craig-Martin

Today's 'real', on the contrary makes no direct appeal to the emotions, nor is it involved in uplift. Indeed, it seems to have no desire at all to justify itself, but instead offers itself for whatever uniqueness is worth – in the form of the simple, irreducible, irrefutable object.
E C Goosen
catalogue 1968 *Art of the Real, USA 1948–1968*

All these quotations are taken from the books, articles or exhibition catalogues listed in the bibliography on page 28.

The Minimal artist makes an effort to deal with the visual equivalents of precisely examined sensations and with the relational or contextural meanings that they require. To do this successfully, the number of elements and relationships used are reduced to an absolute minimum. Experiences most closely associated with what are felt to be primary visual relations are clearly distinguished from those considered to be derivative; for example, those that are classical or romantic in origin.
Allen Leepa

Morris reacted against a sculptural illusionism which converts one material into the signifier for another: stone, for example, into flesh – an illusion that withdraws the sculptural object from literal space and places it in a metaphorical one.
Rosalind Krauss
catalogue 1982 *Minimalism x 4*

ART HISTORY

In 1913, Kasimir Malevich, placing a black square on a white ground that he identified as the 'void,' created the first suprematist composition. A year later, Marcel Duchamp exhibited as an original work of art a standard metal bottle-rack, which he called a 'ready-made'. For half a century, these two works marked the limits of visual art. Now, however, it appears that a new generation of artists, who seem not so much inspired as impressed by Malevich and Duchamp (to the extent that they venerate them), are examining in a new context the implications of their radical decisions.
Barbara Rose

It is Professor Wollheim's contention that the art content of such works as Duchamp's found-objects (that is, the 'unassisted readymades' to which nothing is done) or Ad Reinhardt's nearly invisible 'black' paintings is intentionally low, and that resistance to this kind of art comes mainly from the spectator's sense that the artist has not worked hard enough or put enough effort into his art. But, as Professor Wollheim points out, a decision can represent work. Considering as 'Minimal Art' either art made from common objects that are not unique but mass-produced or art that is not much differentiated from ordinary things, he says that Western artists have aided us to focus on specific objects by setting them apart as the 'unique possessors of certain general characteristics'.
Barbara Rose

In the face of the dominance throughout the 1950s of forms of art laying emphasis on the artist's mobile gesture, the (relatively) informal or loose disposition of materials, or the dramatic projection of the artist's feelings, these artists' work asserted the vitality of order and control. For the histrionics, glamour or weakness of focus, by 1959, of (for example) dribbled or flung paint in the ubiquitous work of minor Abstract Expressionists, they substituted the known quantities of repetition, elementary forms and everyday materials such as wood and bricks. This had a bracing and revitalizing effect on art.
Richard Morphet

Although Minimalism consists primarily of three-dimensional objects, the artists involved responded as much to the impasse they perceived painting to have reached as to modern sculptural traditions. By the end of the 1950s the dominance of reflexively gestural painting was losing its grip on the art world.
Anon
catalogue 1982 *Minimalism x 4*

Nowhere in world art has it been clearer than in Asia that anything irrational, momentary, spontaneous, unconscious, primitive, expressionistic, accidental, or informal, cannot be called serious art.
Ad Reinhardt
in Barbara Rose

The expansion of art education had the effect of challenging the anti-intellectualism traditional in art institutions.
Michael Craig-Martin

To begin in the broadest possible way it should be stated that the concerns of sculpture have been for some time not only distinct from but hostile to those of painting.
Robert Morris

Some years would pass before it became commonplace to say painting was dead, but I do not think painting occupied the foreground of art again until the beginning of the 80s. Many of the most interesting young artists stopped painting and turned to other things. Minimalist sculpture was primarily the work of former painters.
Michael Craig-Martin

The borderline between art and non-art had to be sought in the three-dimensional, where sculpture was, and where everything material that was not art also was.
Clement Greenberg
in Michael Fried

EXPERIENCE: THE SPECTATOR

It is exactly these impingements upon our sense of touch and so forth that I'm interested in. The sense of one's own being in the world confirmed by the existence of things and others in the world.
Carl Andre
leaflet 1978 *Carl Andre*

I like myself art works which sort of ambush you, that in a sense take you by surprise because you can be in a place for some time and not even know that they are there, then suddenly you see them … I don't like art that dominates you, that is coming at you and is assailing you and is making an attack. I like work that is just there until it needs you and you need it.
Carl Andre
leaflet 1978 *Carl Andre*

For the spectator, this is often all very bewildering. In the face of so much nothing, he is still experiencing something.
Barbara Rose

Minimal Art is an effort to deal as directly as possible with the nature of experience and its perception through visual reactions and an effort to relate the observer to the thing observed at that point where human perception brings them together – in the *magic* of the phenomenon of experiencing itself.
Allen Leepa

Words restrict experiences and ideas as well as develop and organize them. We become slaves to the limitations imposed on us by our use of language, at the same time that we organize ourselves in essential ways because of it. Minimal Art attempts to avoid this dilemma by a more direct confrontation with the essential elements of perception itself.
Allen Leepa

The better new work takes relationships out of the work and makes them a function of space, light and the viewer's field of vision.
Robert Morris

EXPERIENCE: SPACE

One of the conditions of knowing an object is supplied by the sensing of the gravitational force acting upon it in actual space. That is, space with three, not two coordinates. The ground plane, not the wall, is the necessary support for the maximum awareness of the object.
Robert Morris

Certainly space rather than form is at the heart of the Minimalist movement, the achievement of Minimalism comes in the development of *an active space* that radically shifts meaning from the object as art to the spectator's awareness of his own perceptions as he or she moves through an often expansive space.
Michael Auping

The standard unit, with its possibilities of repetition, becomes for Carl Andre and Dan Flavin a way of seizing space aggressively, logically and symmetrically.
Kynaston McShine
catalogue 1966 *Primary Structures: Younger American and British Sculptors*

But the concerns now are for more control of and/or cooperation of the entire situation. Control is necessary if the variables of object, light, space, body, are to function. The object itself has not become less important. It has merely become less *self*-important.
Robert Morris

EXPERIENCE: SCALE

The qualities of publicness or privateness are imposed on things. This is because of our experience in dealing with objects that move away from the constant of our own size in increasing or decreasing dimension.
Robert Morris

Much of the new sculpture makes a positive value of large size. It is one of the necessary conditions of avoiding intimacy. Larger than body size has been exploited in two specific ways: either in terms of length or of volume.
Robert Morris

The awareness of scale is a function of the comparison made between that constant, one's body size, and the object. Space between the subject and object is implied in such a comparison. In this sense space does not exist for intimate objects. A larger object includes more of the space around itself than does a smaller one. It is necessary literally to keep one's distance from large objects in order to take the whole of any one view into one's field of vision.
Robert Morris

EXPERIENCE: SHAPE

A Baroque figurative bronze is different from every side. So is a six-foot cube.
Robert Morris

Literalist art stakes everything on shape as a given property of objects, if not, indeed, as a kind of object in its own right. It aspires, not to defeat or suspend its own objecthood, but on the contrary to discover and project objecthood as such.
Michael Fried

Simplicity of shape does not necessarily equate with simplicity of experience.
Robert Morris

The magnification of this single most important sculptural value – shape – together with greater unification and integration of every other essential sculptural value makes, on the one hand, the multipart, inflected formats of past sculpture extraneous, and on the other hand, establishes both a new limit and new freedom for sculpture.
Robert Morris

EXPERIENCE: PRESENCE & TIME

As Andre has remarked, the presence of 120 fire-bricks is very different from the idea of 120 firebricks.
Richard Morphet

The experience of the work necessarily exists in time. *The intention is diametrically opposed to Cubism with its concern for simultaneous views in one plane.*
Robert Morris

Something is said to have presence when it demands that the beholder take it into account, that he take it *seriously* – and when the fulfilment of that demand consists simply of being *aware* of it and, so to speak, in acting accordingly.
Michael Fried

Someone has merely to enter the room in which a literalist work has been placed to *become* that behol-der, that audience of one almost as though the work in question has been *waiting* for him. And inasmuch as literalist work *depends* on the beholder, is *incomplete* without him, it *has* been waiting for him.
Michael Fried

Here finally I want to emphasize something that may already have become clear: the experience in question *persists in time*, and the presentment of endlessness that, I have been claiming, is central to literalist art and theory, is essentially a presentment of endless, or indefinite, *duration*.
Michael Fried

It is this continuous and entire presentness, amount-ing, as it were, to the perpetual creation of itself, that one experiences as a kind of *instantaneousness*: as though if only one were infinitely more acute, a single infinitely brief instant would be long enough to see everything, to experience the work in all its depth and fullness, to be forever convinced by it.
Michael Fried

ANDRE

My arrangements I've found are essentially the sim-plest I can arrive at, given a material and a place …
The one thing I learned in my work is that to make the work I wanted you couldn't impose properties on the materials. You have to reveal the properties of the material.
Carl Andre
leaflet 1978 *Carl Andre*

All I am doing is putting Brancusi's 'Endless Col-umn' on the ground instead of in the sky. Most sculpture is priapic with the male organ in the air. In my work, Priapus is down on the floor. The engaged position is to run along the earth.
Carl Andre
in David Bourdon

Andre continued to investigate place with the use of metal plates to make squares and long rectangles. These floor-bound pieces, which the artist believes activate a column of space above them, are meant to be walked on as well as viewed.
Janet Heit & Gerard McCarthy
catalogue 1982 *Minimalism x 4*

For (again in contrast to work such as Caro's) the work makes a positive statement in employing no joints or bolts. Each brick occupies its position by straightforward placing and gravity alone. Nor, of course, is it painted or is its appearance altered in any way. Moreover, Andre did not even commission its manufacture; the bricks already existed. 'Equivalent VIII' thus exemplifies Andre's concern with greatly reducing the degree of art's traditional interference with things as they are, and with revealing aspects of the world as it is.
Richard Morphet

By its simplicity of form, work such as 'Equivalent VIII' reveals more than merely physical aspects of the world as it is. It draws clear attention to the steps (of selection and acquisition of the work's materials, and of the process of placing them, involving both adv-ance calculation and a physical act) which the artist undertook or authorized in order to make the work.
Richard Morphet

FLAVIN

Flavin's light actualizes the potential nonfictive space – suggested in Rothko's paintings – by creating an environmental art in which viewer, space and art object become an indivisible whole. His installations do not simply cover walls. They engulf a room not only highlighting the architectural background but also filling and activating the normally passive spaces they inhabit. The spectator finds himself in a nimbus like volume, a total field that eliminates the physical and implied psychological distance that normally exists between viewer and art object.
Michael Auping

Dan Flavin's work did not seem important to me until I happened to see one of his pieces unplugged. The feeling I got about his unlighted piece was not exactly that it was no longer 'a Flavin' or just a piece of mounted hardware; I felt rather that something was missing from the piece, absent or away from it. To say that light was absent from it is not really to say anything. My temptation is to say I feel absent from the piece.
Kenneth Baker

JUDD

It isn't necessary for a work to have a lot of things to look at, to compare, analyse one by one, to contemplate. The thing as a whole, its qualities as a whole, is what is interesting.
Donald Judd
in Suzi Gablik

These structures (dams, bridges, roads, etc) are art and so is everything made. It is better to consider art and non-art one thing and make the distinctions ones of degree. Engineering forms are more general and less particular then the forms of the best art.
Donald Judd

LEWITT

The most interesting characteristic of the cube is that it is relatively uninteresting … it is best used as a basic unit for any more elaborate function, the grammatical device from which the work may proceed.
Sol LeWitt
catalogue 1982 *Minimalism x 4*

The form itself is of very limited importance; it becomes the grammar of the total work.
Sol LeWitt
catalogue 1982 *Minimalism x 4*

MORRIS

In grasping and using the nature of made things the new three-dimensional art has broken the tedious ring of 'artiness' circumscribing each new phase of art since the Renaissance. It is still art. Anything that is used as art must be defined as art.
Robert Morris

Simplicity of shape does not necessarily equate with simplicity of experience. Unitary forms do not reduce relationships. They order them … they are bound more cohesively and indivisibly together.
Robert Morris

SERRA

I stood up the four lead plates which I had been using as props. The plates overlapped each other for about 5cms, and weighed 220kgs. It all at once became clear to me that it was not exclusively the properties of the material which interested me, but that my work would fulfil all the criteria of a sculpture: it had volume, weight, mass and one could walk around it. From this moment onwards I was concerned with the nature of sculpture.
Richard Serra
in Michael Auping

All works are in the Tate Gallery Collection unless otherwise stated. The dimensions are given in millimetres, height before width before depth.

CARL ANDRE b.1935

American Minimal sculptor and poet. Born in Quincy, Massachusetts. In 1954 worked for Boston Gear Works and travelled to England and France. Served in the US Army 1955-6. In 1957 moved to New York and worked for a publisher. Wrote poetry and made drawings and some abstract sculptures in 'Perspex' and wood, with geometric forms. Influenced by the sculptor Constantin Brancusi and by the American painter Frank Stella, his close friend. 1960-4 worked as railroad freight brakesman and conductor on the Pennsylvania Railroad; made few sculptures, but these reveal a move away from carving to works constructed out of simple blocks of material. His sculpture first exhibited in a group show in 1964, followed by his first one-man exhibition at the Tibor de Nagy Gallery, New York, 1965; major retrospective exhibition at the Guggenheim Museum, New York, 1970. Made floor sculptures out of standard industrial units such as bricks or metal plates in simple arithmetic combinations.

Equivalent IV 1966/69
Firebricks, 120-unit rectangular solid,
2 high x 15 header x 4 stretcher
127 x 1714 x 914
Private collection, London

Equivalent VI 1966
Firebricks, 120-unit rectangular solid,
2 high x 5 header x 12 stretcher
127 x 2740 x 570
Saatchi Collection, London
(see illustration on page 22)

Equivalent VIII 1966
Firebricks, 120-unit rectangular solid,
2 high x 6 header x 10 stretcher
127 x 686 x 2292
T01534. Purchased 1972
(see illustration on page 23)

In the summer of 1965, while canoeing on a New Hampshire lake, Carl Andre realised he wanted his sculpture to be as low and level as water. Andre's exhibition of these brick pieces at the Tibor de Nagy Gallery in 1966, consisting of eight 'islands' of bricks placed in meticulous rectilinear relationships within the gallery space, was indicative of his growing interest in environment.

The number 120 was chosen because it was particularly rich in factors. The bricks had to be stacked in two layers to prevent them drifting apart and to give the pieces sufficient mass. Thus the top layer of each mound had only 60 bricks. The bricks were assembled in only four out of six possible combinations: 3 x 20, 4 x 15, 5 x 12 and 6 x 10, each of these combinations creating two possible shapes. (In bricklaying, bricks laid end to end are called a stretcher course and bricks laid side by side are called a header course; thus the pieces may be described as 120 bricks in two courses each, ie 3 header x 20 stretcher and 3 stretcher x 20 header etc.) The same 6 x 10 combination, for example could be either an elongated rectangle or a near square, depending on the orientation of the bricks. Although each of the eight shapes was different, they all occupied the same amount of space in cubic centimetres, which accounted for their visual equivalence. He therefore entitled this exhibition *Equivalents* (which was also the title of Alfred Stieglitz's series of cloud photographs).

After the exhibition, Andre returned all but 200 of the bricks to the brickyard to get his money back. The original bricks were sand-lime bricks from the Long Island City Brickworks. When he decided to reconstruct the pieces several years later he found that this brickworks had closed, so he used firebricks instead. These are approximately the same size, but

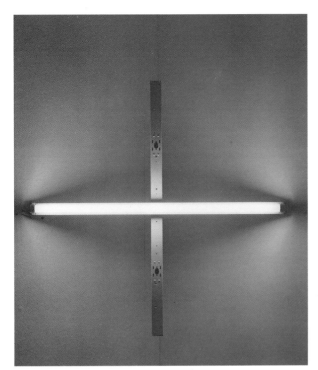

DAN FLAVIN *Untitled (Corner Piece)* 1969

DAN FLAVIN b.1933

American artist who has worked mainly with fluorescent light. Born in New York. Served in the meteorological branch of the US Air Force and then at the National Weather Analysis Centre. Almost no formal instruction in painting apart from four sessions at the Hans Hofmann School, New York, in 1956, but attended Columbia University 1957-9 to study art history. Made drawings and small paintings in gestural Abstract Expressionist styles and small constructions incorporating found objects; first one-man exhibition of these at the Judson Gallery, New York, 1961. Began in 1961 to make 'icons' combining electric lights with plainly painted square-fronted constructions. In 1963 began to work with fluorescent installations for particular spaces, eg for *Documenta 4* at Kassel 1968, the National Gallery of Canada 1969 and the St Louis Art Museum 1973.

yellowy-brown instead of bluish-white. Only one brick piece made of sand-lime survives, a 6 x 10 configuration belonging to Mr and Mrs Manuel Greer, New York. He remade all the brick pieces in 1969, including a second version of this sand-lime piece. It was important that the bricks should be light in colour, without holes.

Andre emphasised that a key change for him was the move from cutting into materials (as in the case of 'Last Ladder') to constructing works out of standard units which were already cut.

'Monument' for V Tatlin 1966
Cool white fluorescent light
3658 x 710 x 110
Saatchi Collection, London
(see illustration on page 21)

Untitled (Corner Piece) 1969
Fluorescent tubes on metal backing
1225 x 1225 x 203
T01824. Purchased 1973
This work consists of two 122cm fluorescent 'quick start' fittings bolted together in the configuration of a cross; a vertical tube on the inside and a horizontal blue on the outside. It is designed to span a corner at eyelevel height, and combines direct and reflected light. The Tate's piece is the second of an edition of five. It is Flavin's practice to make his small works (up to 1219mm) in editions of five, and his larger works in editions of two or three. Other versions have been executed such as a 609mm multiple made in Munich which was blue in the front and pink at the back (published in an edition of 40, plus 10 for himself), and a 1219mm version in white.

He added that this configuration did not have any symbolic significance for him and was just a form

that worked well and made use of the corner. Asked whether his corner pieces could have been influenced at all by the Russian Constructivist artist Tatlin's corner reliefs, he agreed that some connection was possible.

His first installation spanning a corner was made in February 1966. It consisted of a 1828mm pink strip in front and a 609mm gold strip at the back, the whole shaped like an inverted T, and was mounted low down, about 150mm from the floor. It made use of the corner to trap the light and to produce an illuminated colour mix. His first work to give the impression of taking the corner away, or dissolving it, was a square with white fluorescent light made for an exhibition in December 1966.

DONALD JUDD b.1928

American sculptor and writer on art. Born in Excelsior Springs, Missouri. Studied at the Art Students League, New York, 1948 and at the College of William and Mary, Williamsburg, 1948-9; later took degree courses in philosophy 1949-53 and art history 1957-62 at Columbia University. First one-man exhibition at the Panoras Gallery, New York, 1957. 1959-65 a contributing editor to *Arts Magazine* and reviewer for *Arts News* and *Art International*. Began as a painter, his paintings developing in the early 1960s into low reliefs, then into high-reliefs and free-standing works. Made wall pieces and floor pieces with precise geometrical forms and without a base. His earliest sculptures were mainly in wood, but after the exhibition at the Green Gallery, New York in 1963-4, which established his reputation, he began to have his pieces fabricated from his designs in metal and sometimes coloured 'Perspex'.

Untitled 1967
Green lacquer on galvanised iron
368 x 1943 x 648
Saatchi Collection, London
(see illustration on page 24)

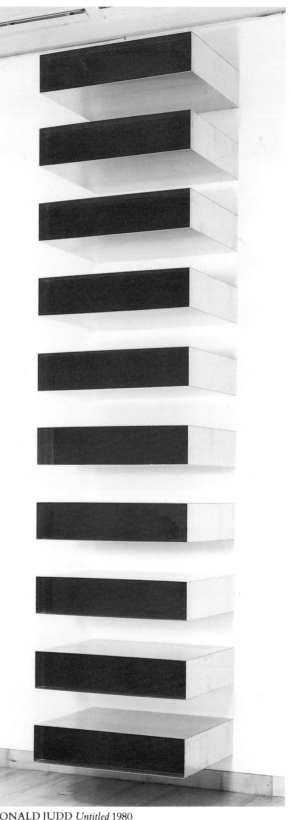

DONALD JUDD *Untitled* 1980

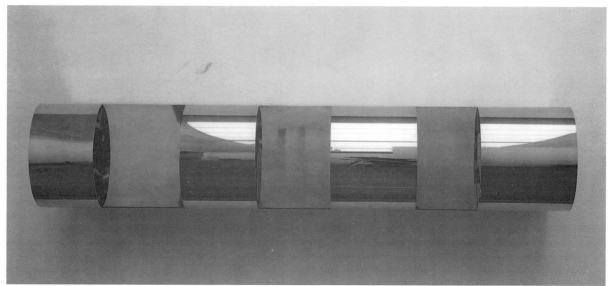

DONALD JUDD *Untitled* 1973

Untitled 1973
Copper
371 x 1943 x 749
T01727. Purchased 1973
Like much of Judd's work, this sculpture was fabricated to his specifications by Bernstein Bros, a metal-working firm in Long Island City, New York. The figures 72-21 stamped on the flange at the back mean that this was the twenty-first Judd work ordered by the Leo Castelli Gallery, New York, in 1972, and the initials JO are those of José Otero, the mechanic who made it.

Brydon Smith, one of the three authors of the *catalogue raisonné* of Judd's sculpture, writes of this work (letter of 13 August 1975):

The widths of the bullnose projections increase arithmetically by 1.5 inches. The widths of the spaces equal the first three projections but in the reverse order. Judd used this kind of series in all the square and bullnose fronted progressions.

Untitled 1980
Galvanised steel with aluminium reinforcements and inset blue 'Perspex' panels
10 units, each 228 x 1016 x 787
T03087. Purchased 1980
(see illustration on previous page)
'Untitled' 1980 (T03087) was made for Judd by Bernstein Bros (see entry for 'Untitled' 1973 (T01727)).

Donald Judd has produced similar arrangements of identical rectilinear metal units since 1965. These units, which are cantilevered off the wall at regular intervals, one above the other, are often referred to as 'stacks' and are made in two sizes. In the smaller versions, each unit measures 1524 x 685 x 609mm, and in the larger versions (for example, T03087) the dimensions of each unit are 228 x 1016 x 787mm.

With the exception of the first of these arrangements, a large galvanised iron 'stack' comprising seven five-sided boxes, completed in June 1965, each 'stack' is composed of a minimum of ten units. A work refabricated in 1974 has 12 units. However the number of units used in an installation is governed by the ceiling height of the exhibition space. When a 'stack' is correctly installed, the space between each unit and between the bottom unit and the floor, equals the height of an individual unit. In the case of large format 'stacks', like T03087, this is 229mm. The space between the top unit and the ceiling should be no less than the height of one unit.

SOL LEWITT b.1928

American sculptor, draughtsman, lithographer and etcher. Born in Hartford, Connecticut. Studied at Syracuse University, New York, 1945-9. Abandoned painting in 1962 and began to experiment with abstract black and white reliefs, followed in 1963 by relief constructions with nested enclosures projecting into space, and box- and table-like constructions. First one-man exhibition at the Daniels Gallery, New York, 1965. Since 1965-6 has worked in series using a simple form such as an open or closed cube as a module to create structures in accordance with a pre-determined, logical system. Starting in 1966 with *Serial Project No 1* he also published a series of books constituting a parallel system. Wrote an influential article 'Paragraphs on Conceptual Art' first published in 1967. Taught at the Museum of Modern Art School, New York, 1964-7, at Cooper Union, New York, 1967-8, at the School of Visual Arts, New York, 1969-70 and at New York University from 1970. Began in 1968 to create wall drawings, to be carried out by himself or others in accordance with his specifications, and has also produced series of lithographs, etchings and screenprints.

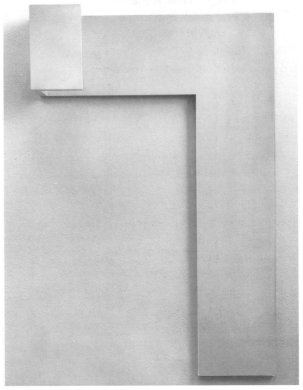

SOL LEWITT *Untitled* 1965

Untitled 1965
Painted aluminium relief
1841 x 1216 x 305
T03097. Purchased 1980

Sol LeWitt made two versions of this structure. The prototype was one of a number of painted wood constructions in his first one-man exhibition at the John Daniels Gallery, New York, in May 1965. LeWitt later wrote 'The pieces I showed there were fairly large and simple slabs. Using lacquer, much work was done to make the surface look hard and industrial. This was negated by the grain of the wood. They should have been made in metal as some of them were later, but I could not afford it.'

In a letter (27 May 1983) the artist confirmed that the first version of T03097 was made for exhibition at the Daniels Gallery. 'It was made of wood by myself and painted (I believe) dark red or brown. I traded this piece to another artist, Leo Valledor, who lives in San Francisco. The piece is still there. The second, aluminium, or steel version was made in 1967, at Bergeyk Holland ... or in Dusseldorf (where I don't know). It was shown at the *Prospect '68* ... I don't know what happened to it, although the piece you have is undoubtedly it.'

In the same letter, the artist confirmed that, although the dimensions of T03097 and its predecessor do not conform exactly, the work was planned on the following serial progression 8, 4, 2, 1, ie, the height of the work is halved in the horizontal member, which is itself halved in the horizontal section, which has been bent or folded away from the wall; this latter section is halved again by the final right angle.

Two open modular cubes/half-off 1972
Baked enamel on aluminium
1600 x 3054 x 2330
T01865. Purchased 1974
(see also colour illustration on front cover)

This sculpture is one of a group on the same scale using the cube as a building block or module in various simple combinations. The basic piece within the group consists of a single cube. Then there are pieces with two cubes one on top of the other, three cubes in a row and five in a row; also three forming a right angle, four forming a square and five forming a cross. The Tate's is the key example of the half-off pieces in which the cubes abut along half their sides instead of being aligned. This idea is developed further in a piece with not two but three half-off cubes, and another with five half-off cubes alternately projecting and receding in a zig-zag. There are also two pieces with two cubes in a line and either one or two cubes set half-way along the side; another with two cubes surmounted in the centre by a third; one with two cubes in a line and double cube, one on top of the other, half-way along the side; and one with three cubes forming a right angle and the corner cube surmounted by a fourth cube.

The artist said in April 1975 that these works should not be regarded as a series but simply as a group of related pieces. He has not attempted to explore all the possible permutations but picked out those which were 'the most poignant (simple, basic, intelligible)'. Though he has made other sculptures with a larger number of cubes, the units were much smaller. None of the works in this group includes more than five cubes; otherwise the resulting overall size (based on this scale) would be too large.

The large versions such as the Tate's were made to the human scale and are 1600mm high, approximately his own eye-level. They were fabricated from pre-existing 150mm square steel or aluminium tubing and the ratio of bar to space is 1:8.5. The fabrication was carried out by a company in Holland, apart from several pieces made in New York. Each sculpture can be dismantled and is then reassembled by slotting the pieces together. The elements have been stove enamelled, but the artist said that any white, not-too-glossy, semi-permanent surface would be equally good.

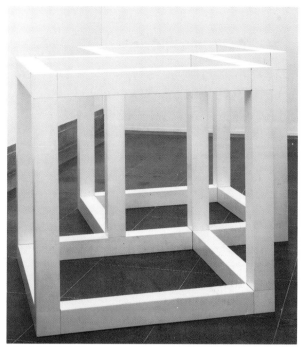

SOL LEWITT *Two open modular cubes/half-off* 1972

Each sculpture is unique but exists on two scales, large and small, the height of the smaller cubes being 200mm. The first small-scale versions were made in 1965; the first large-scale in 1969.

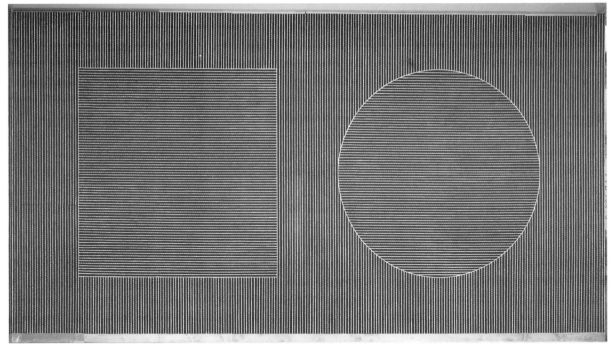

Six Geometric Figures (+ Two) (wall drawings) 1980-1
On four black walls, white vertical parallel lines, and in the centre of the walls, eight geometric figures (including cross, X.) within which are white horizontal parallel lines. The vertical lines do not enter the figures.
White chalk, or white crayon and matt black emulsion paint on wall surface
Dimensions variable
T03100. Purchased 1980
This is the second wall drawing by Sol LeWitt to be acquired by the Tate. The work's descriptive title, as given above, gives the basic specification for the drawing. In reply to a request for rules governing the correct future installation of this work and the variants within which it can operate, the artist wrote (letter, 27 May 1983): 'The distance between the lines remains at 40mm. The drawing always should be large and compensated by any architectural irregularities. If the wall height is 10 feet or less, the figures can be shortened to 8 feet. The six figures are the circle, square, triangle, rectangle, trapezoid and parallelogram. The two added are cross and X, in that sequence if possible. The distance between the figures and the edge of the wall is variable. All lines within the figures are horizontal and parallel. All

SOL LEWITT *Six Geometric Figures (+ Two)*
(wall drawings) 1980-1 (detail)

drawing can exist with any number of the figures from one to eight but must be done in the same sequence if more than one is used. Any single figure may be used at any time. The cross and X could be used as a double but the first group (circle, square, triangle) should be kept together, also the second (rectangle, trapezoid, parallelogram). They may be used separately. The drawing may be banked [(a) circle, square, triangle (+)b) rectangle, trapezoid, parallelogram (x)].'

It may be loaned while still installed at the Tate by being drawn elsewhere. The drawing should be done by an experienced draughtsperson. A white crayon may be used instead of white chalk – but the lines must be truly white. The crayon smudges less.

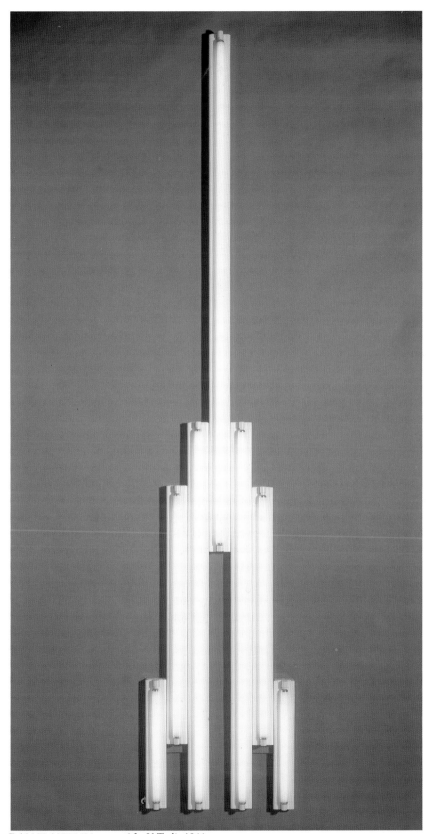

DAN FLAVIN *'Monument' for V Tatlin* 1966

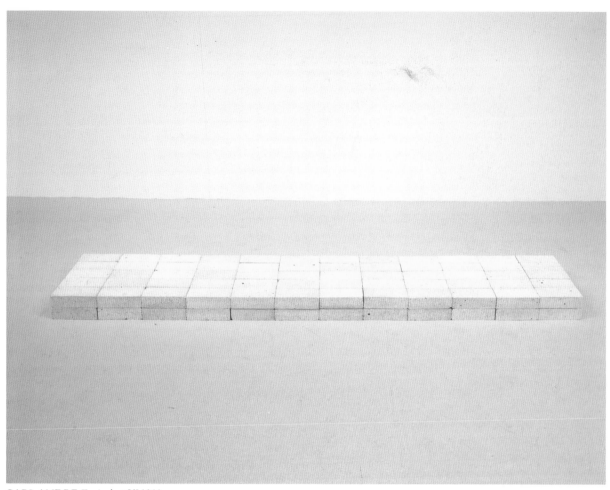

CARL ANDRE *Equivalent VI* 1966
Firebricks, 120-unit rectangular solid,
2 high x 5 header x 12 stretcher

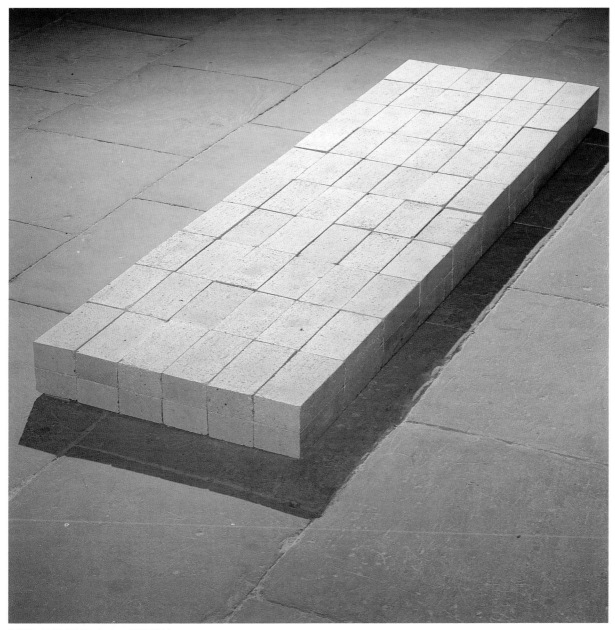

CARL ANDRE *Equivalent VIII* 1966
Firebricks, 120-unit rectangular solid,
2 high x 6 header x 10 stretcher

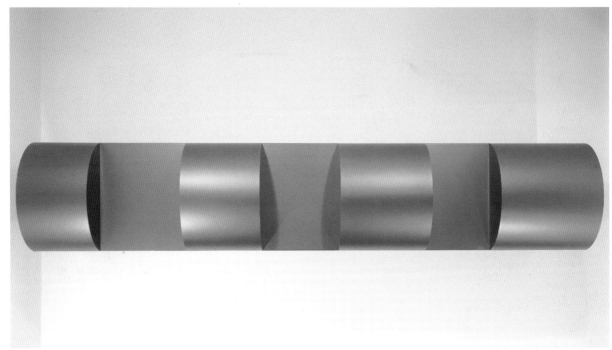

DONALD JUDD *Untitled* 1967

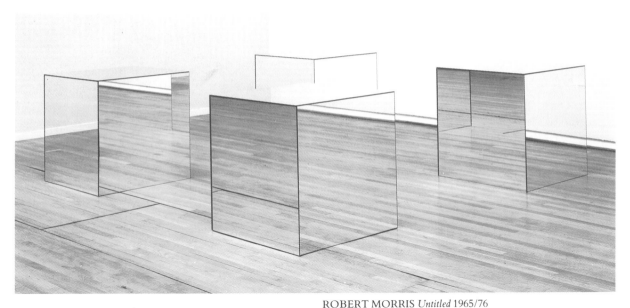

ROBERT MORRIS *Untitled* 1965/76

ROBERT MORRIS b.1931

American sculptor, painter and writer on art, born in Kansas City. Studied engineering at the University of Kansas City and art at Kansas City Art Institute 1948-50, the California School of Fine Arts, San Francisco 1951 and Reed College, Oregon 1953-5. Returned to San Francisco and worked in improvisatory theatre, film and (until 1959) paintings, and had his first one-man exhibition of paintings at the Dilexi Gallery, San Francisco, in 1957. Moved to New York in 1961 and began to make sculpture. Studied art history at Hunter College, New York 1962-3, writing a dissertation on Brancusi. His early sculptures were mainly neo-Dada, small-scale lead reliefs and mixed media works concerned with process, information and paradox, followed by completely abstract, geometric Minimal sculptures in painted plywood and later in fibreglass or metal. Published a series of articles on sculpture in *Artforum* from 1966. Also began in 1967 to make soft hanging sculptures in felt and from 1968 to produce anti-form or process works by lateral spreading, scattering or stacking of different materials. His later work includes a number of projects for large-scale monuments and earthworks. Organised the Peripatetic Artists Guild in 1969, announcing his availability to carry out commissions anywhere in the world.

Untitled 1965/76
Mirror plate glass on board
Four pieces each 915 x 915 x 915
T01532. Purchased 1972
Morris' first set of four mirror boxes was made in 1965 for his exhibition at the Green Gallery, New York, in February 1965, but he subsequently destroyed it because the boxes were made of 'Perspex' and the mirroring would not stick on.

This example is one of three or four versions, most probably only three as this is his usual limit. The Tate's version was first fabricated in London in 1971 for his exhibition at the Tate Gallery, and then re-made in 1976 with his permission, in more permanent materials (3mm Sandersilver Mirror SQ over Aeroweb F-Board cubes). A further version the same size in highly polished stainless steel was made in 1974 for the Sonnabend Gallery, New York, the advantage of stainless steel being that it does not break.

The artist has said that: 'Originally the space between the boxes was equal to the combined volume of the 4 boxes, but I haven't followed that rule recently and generally place them more with regard to the space of the room – always maintaining enough room – some 5 or 6 feet at minimum – between them for walking'.

RICHARD SERRA b.1939

American sculptor, draughtsman and film-maker, born in San Francisco. Studied at the University of California (Berkeley and Santa Barbara) 1957-61 and at Yale University School of Art and Architecture, New Haven, 1961-4. Lived in Paris and Italy 1964-6, then settled in New York, where he met the artists Eva Hesse, Donald Judd, Bruce Nauman, composer Steve Reich and others. First one-man exhibition at the Galleria La Salita, Rome, 1966. Worked 1966-7 mainly with rubber, including hanging units like thick harness juxtaposed with a tangled network of neon lights. Then he turned to floor pieces: a horizontal wooden form with lighted candles, floor sheets in moulded latex rubber, torn and scattered crumpled pieces of sheet lead, and splashed molten lead. Began in 1969 to be primarily concerned with the cutting, propping or stacking of lead sheets, rough timber, etc, to create structures, some very large and supported only by their own weight; emphasising the process of making and the character of the material. Also made films concerned with process, eg *Hand catching lead* 1968. Since 1970-1 has made various large-scale exterior and landscape pieces, as well as monumental black drawings in charcoal or paintstick.

Shovel Plate Prop 1969
Lead (The work comprises two elements, a lead sheet and lead roll)
2502 x 2000 x 800
T01728. Purchased 1973
Richard Serra first began to explore the possibilities of lead in 1968 by ripping away by hand the successive edges of a lead square so that the floor was strewn with a chaotic accumulation of lead 'tears'. Then towards the end of the same year he made his first lead prop piece and also his first lead splashing by tossing molten lead at the juncture of floor and wall.

The first prop piece was done for the Galerie Ricke in Cologne in October 1968. It consisted of a flat sheet of lead held in place against the wall some 80cm or so above the floor by a lead roll like a pole leaning against it towards the top. Another similar work of different proportions was erected a few weeks later, in December 1968, at the Castelli warehouse in New York.

The present work was made in Cologne in March 1969 for an exhibition at the Galerie Ricke. Serra created twelve works in the Galerie Ricke at this time, ten made out of lead and two out of neon; they included five prop pieces, all very different. All these prop pieces explore effects of propping massive forms together purely by weight and gravitational pull. The earliest of them all use the wall as a support. The first free-standing piece was his 'One Ton Prop (House of Cards)' made for the *Anti-Illusion* exhibition at the Whitney Museum in May 1969.

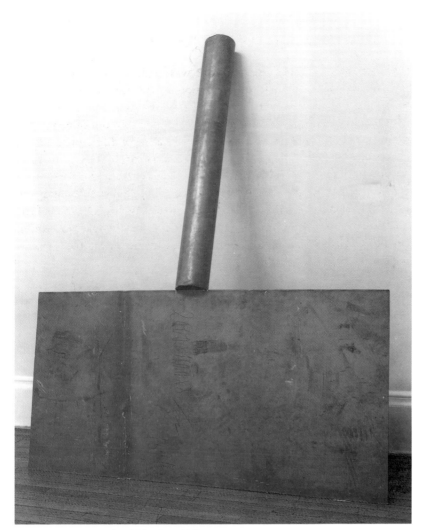

RICHARD SERRA *Shovel Plate Prop* 1969

BOOKS & ARTICLES

Michael Auping, 'Beyond the Sublime' in Michael Auping, ed., *Abstract Expressionism, the critical developments*, London, 1987.

Kenneth Baker, 'A Note on Dan Flavin' *Artforum*, January 1972.

Gregory Battcock, *Minimal art: a critical anthology*, London, 1969. (including below-mentioned articles by Bourdon, Fried, Leepa, Morris, Rose and Wollheim)

David Bourdon, 'The Razed Sites of Carl Andre', *Artforum*, October, 1966.

Michael Craig-Martin, 'Reflections on the 1960s and early '70s', *Art Monthly*, March 1988.

Studio 177, special issue devoted to minimal art, April 1969.

Michael Fried, 'Art and Objecthood', *Artforum,* June 1967.

Suzi Gablik, 'Minimalism', in Nikos Stangos, ed., *The Concepts of Modern Art,* London, 1988.

Donald Judd, 'Donald Judd's View', *Blueprint,* No. 44, February 1988.

Allen Leepa, 'Minimal Art and Primary meanings', see Battcock.

Richard Morphet, 'Carl Andre's Bricks', *Burlington Magazine, CXVIII,* 1976.

Robert Morris, 'Notes on Sculpture', *Artforum,* February and October 1966.

Barbara Reise, 'Untitled 1969: a Footnote on Art and Minimal-stylehood,' *Studio International,* Vol. 177, No. 910, April 1969.

Barbara Rose, 'ABC Art', *Art in America,* October-November, 1965.

Richard Wollheim, 'Minimal Art', *Arts Magazine,* January, 1965.

EXHIBITIONS

1964 *Eight Young Artists*, The Hudson River Museum, Yonkers, New York and Bennington College, Vermont.

1965 *Flavin, Judd, Morris, Williams*, Green Gallery, New York.

1965 *Shape and Structure*, Tibor de Nagy Gallery, New York.

1966 *Primary Structures: Younger American and British Sculptors*, The Jewish Museum, New York.

1966 *10,* Dwan Gallery, New York and Los Angeles.

1967 *American Sculpture of the Sixties*, Los Angeles County Museum of Art and Philadelphia Museum of Art.

1968 *Minimal Art*, Gemeentemuseum, The Hague; Städtische Kunsthalle, Düsseldorf; Akademie der Künste, Berlin.

1968 *Prospect 68*, Städtische Kunsthalle, Düsseldorf.

1968 *Documenta 4*, Kassel.

1968-69 *Art of the Real, USA 1948-1968,* The Museum of Modern Art, New York; Grand Palais, Paris; Kunsthaus, Zurich; Tate Gallery, London.

1978 *Carl Andre*, Whitechapel Art Gallery, London.

1980 *Pier and Ocean, Construction in the Art of the 70's*, Hayward Gallery, London.

1982 *Minimalism x 4*, Whitney Museum of American Art, Downtown Branch.

1984 *American Art, Minimal Expression*, Tate Gallery, London.

1984 *Blam! The Explosion of Pop, Minimalism, and Performance 1958-1964,* Whitney Museum of American Art, New York.